Pennsylvania

What's So Great About This State?

There is a lot to see and celebrate...just take a look!

CONTENTS

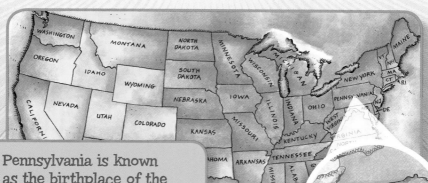

Pennsylvania is known as the birthplace of the nation. The Constitution and Declaration of Independence were both "penned," or written, here!

Well, how about...

the land!

From Lake Erie...

Pennsylvania is a rectangular-shape state located in the mid-Atlantic region of the United States. It is more than 44,000 square miles in size, and over half of this land is covered in beautiful forests!

From the low sandy beaches of Lake Erie to the high mountains of the Appalachians, Pennsylvania is loaded with interesting landforms. And what lies beneath the land's surface is just as amazing! Rich reserves of coal, oil, and natural gas have been found in many areas throughout the state.

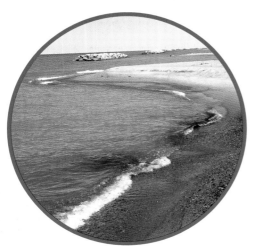

One of the many beaches found in Presque Isle State Park on the shores of Lake Erie in the northwestern part of the state.

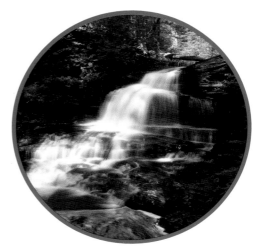

One of the many waterfalls found in Ricketts Glen State Park in the northeastern part of the state.

...to the Delaware River

Pennsylvania is also known for its rich soil. This means that farming is big. Wheat , corn, sweet cherries—lots of different crops are grown. But farms don't just grow plants. Pennsylvania is one of the leading producers of dairy products and meats so you can bet plenty of cows and chickens are raised there as well!

Pennsylvania has so many wonderful places! So take a closer look at the next few pages to get a "big picture" view—then decide which areas you might want to explore some more.

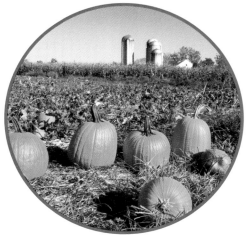

From wheat to pumpkins, the rich soil in Pennsylvania is good for growing many different crops.

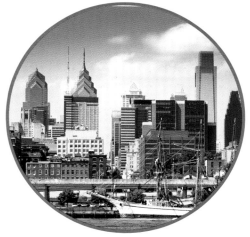

Philadelphia, the state's largest city, is in the southeastern part of the state.

Forests explode in color throughout Pennsylvania in the fall.

Plateaus, Ridges, and Valleys

ALLEGHENY PLATEAU

RIDGE AND VALLEY

The Allegheny National Forest is part of the northern Allegheny Plateau region.

As you can see from the map, the *Allegheny Plateau* and the *Ridge and Valley* regions are big. In fact, the Allegheny Plateau includes more than half the land in the state!

What's so special about the plateaus and mountains?

If you could look at the state of Pennsylvania from a bird's-eye view, you would see that mountain ranges make a diagonal cut across the state. The Allegheny Mountains—part of the larger Appalachian Mountains—help form the western border of the Ridge and Valley region.

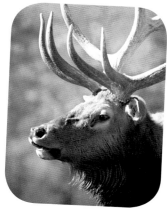

Forests in these regions provide habitats for a variety of plants and animals. And deep valleys have fertile soil for producing such crops as oats and hay.

The largest herd of elk in the eastern United States roams the Allegheny Plateau.

But that's not all!

Rich resources lie beneath the ground in many of these areas. The mining of coal, oil, and natural gas has played an important role in Pennsylvania's development. In fact, the first oil well in the United States was drilled in the Allegheny Plateau region—near Titusville in 1859.

What kinds of things can I see in these regions?

White-tailed deer roam through the thick forests. Brown bats surge from caves. It's amazing how many different types of plants and animals (including bears!) are in these Pennsylvania regions.

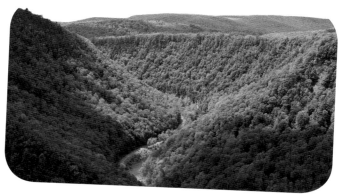

Did you know that Pennsylvania has its own "Grand Canyon?" Pine Creek Gorge has been named a National Natural Landmark. At its deepest point, the Gorge drops more than 1,000 feet.

Piedmont and Plains

ERIE
PLAIN

ATLANTIC
COASTAL
PLAIN

PIEDMONT →

A typical Amish farm in the Piedmont area known
as Pennsylvania Dutch Country operates, or "runs,"
without using electricity or cars.

The lowest and flattest land in the state can be found in the two plains regions. The *Erie Plain* borders Lake Erie in the northwest. Kitty-corner from the Erie Plain, the *Atlantic Coastal Plain* lies in the southeast. Land begins to rise just west of the Atlantic Coastal Plain where the *Piedmont* region begins.

What's so special about these regions?

Plains are generally flat areas of land. That makes them good places to build cities. Erie is a large city in (of course!) the Erie Plain region. Philadelphia, the largest city in Pennsylvania, is in the Atlantic Coastal Plain.

The Piedmont region is known for having some of the best soil in the state. Farms with lots of crops and livestock dot the gently rolling hills in this area.

Where's the Pennsylvania Dutch Country? (...and how did it get its name?)

Pennsylvania Dutch Country is part of the Piedmont region in southeastern Pennsylvania. Many of the earliest settlers to this area in the late 17th and 18th centuries spoke German, or Deutsch. "Deutsch" eventually became "Dutch," but it refers to German heritage. This area is known for its local Amish and Mennonite populations who favor a more traditional lifestyle.

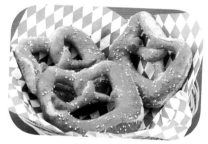

Wheat grown in the Piedmont can be made into flour—which can then be used to make delicious handmade pretzels!

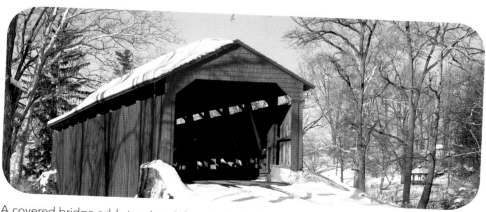

A covered bridge adds to winter's beauty in the Piedmont area of Pennsylvania.

Rivers and Lakes

This is a beautiful section of the west branch of the Susquehannah River around Hyner, Pennsylvania.

Pennsylvania is known for its thousands of miles of lovely creeks and rivers. Some are pretty long and big, too! The Delaware River forms the eastern border of the state. The Susquehanna River cuts through the mountains and zigzags through the interior part of the state. The Allegheny and Monongahela Rivers join at Pittsburgh to form the Ohio River.

Lake Erie forms about fifty miles of the state's border in northwestern Pennsylvania. But plenty of other smaller lakes can be found throughout the state.

Why are lakes and rivers so special?

The state's large rivers—along with Lake Erie—have helped make Pennsylvania an important trade and transportation center for centuries. They also provide recreation, food, drinking water, and habitats throughout the Keystone State.

By the way...why is Pennsylvania called the Keystone State, anyway?

No one knows for sure! But one theory has to do with how the land is situated. During colonial times Pennsylvania was the middle colony of the original thirteen. It had six states located above it and six states below it.

So some thought the state was like a keystone—the piece in the middle of a doorway or arch that holds everything together!

No matter where the nickname comes from, one thing is for sure. The Keystone State's lakes and rivers are some of the most beautiful in the United States.

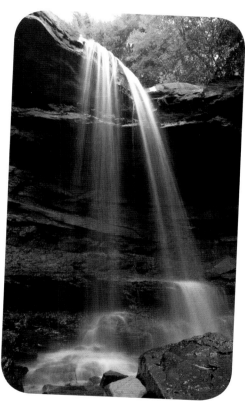

This is Cucumber Falls in the Ohiopyle State Park—which is located along the Youghiogheny River. If you want more action, you can go whitewater rafting along the lower and middle sections of the "Yough" (as the locals call it!).

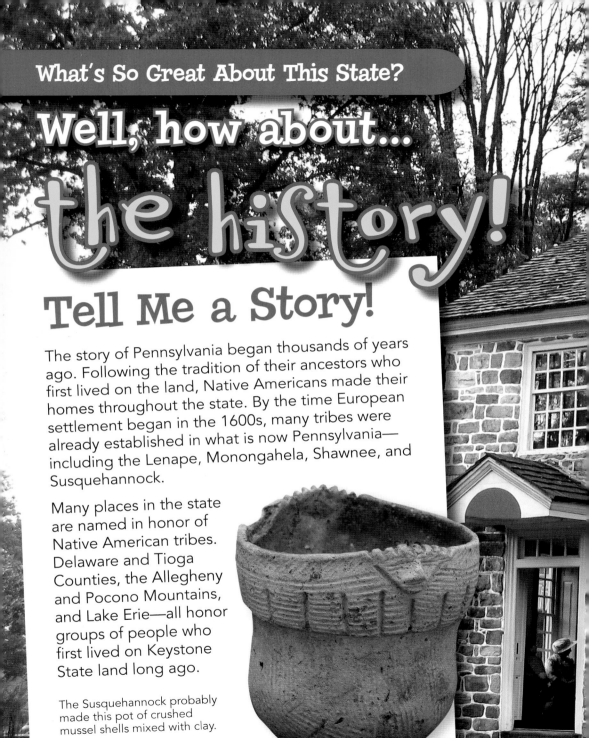

Well, how about...
the history!

Tell Me a Story!

The story of Pennsylvania began thousands of years ago. Following the tradition of their ancestors who first lived on the land, Native Americans made their homes throughout the state. By the time European settlement began in the 1600s, many tribes were already established in what is now Pennsylvania—including the Lenape, Monongahela, Shawnee, and Susquehannock.

Many places in the state are named in honor of Native American tribes. Delaware and Tioga Counties, the Allegheny and Pocono Mountains, and Lake Erie—all honor groups of people who first lived on Keystone State land long ago.

The Susquehannock probably made this pot of crushed mussel shells mixed with clay.

...The Story Continues

Eventually, Pennsylvania became home to many other groups, including Swedish, Dutch, and English explorers; European and American settlers; and African Americans. Many battles for independence were fought in Pennsylvania. In fact, Pennsylvania was one of the main battlegrounds during both the Revolutionary and Civil Wars.

But history isn't always about war. Many great educators, painters, writers, inventors, builders, and others have contributed to the state's history along the way. You can see evidence of this all over the Keystone State!

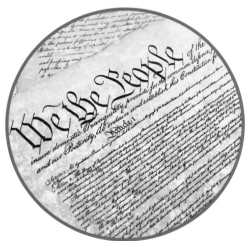

The United States Constitution was signed at the Constitutional Convention in Philadelphia, Pennsylvania, in 1787. The most famous Pennsylvania delegate to sign the Constitution was Benjamin Franklin.

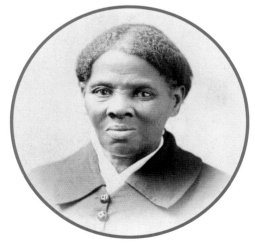

In the 1840s, Harriet Tubman, an enslaved woman, escaped to Pennsylvania. She became a "conductor" on the Underground Railroad—helping hundreds of others escape from slavery to freedom in the North.

MONUMENTS

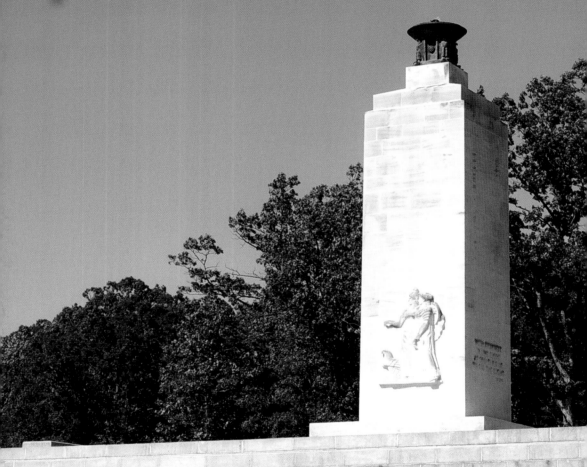

On July 3, 1938, former Union and Confederate soldiers met to dedicate the Eternal Light Peace Monument in Gettysburg National Military Park.

Monuments honor special people or events. Monuments also tell stories. The Gettysburg National Military Park has more than 1,400 monuments and markers that honor the soldiers of the Civil War, both Union and Confederate, who fought in the Battle of Gettysburg.

Why are Pennsylvania monuments so special?

They're special because they honor so many special people who helped build the Keystone State. Some were famous people. Others were just ordinary citizens who did extraordinary things to help shape both the state of Pennsylvania and the nation.

Where are these monuments found?

Almost every town has found some way to honor a historic person or event with statues, plaques, named streets, or cornerstones. In fact, more than two thousand historical markers have been placed throughout the state to honor the memory of people, places, and events in Pennsylvania.

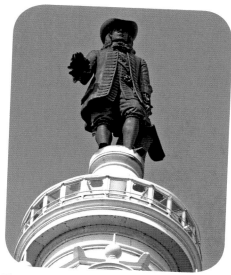

This statue on top of the Philadelphia City Hall honors the founder of Pennsylvania, William Penn.

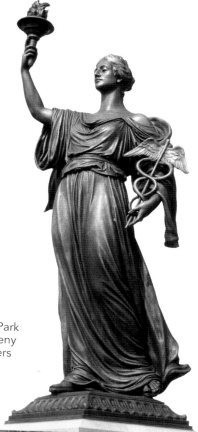

This bronze statue in Schenley Park in Pittsburgh honors the Allegheny County Medical Society Members who served in World War I.

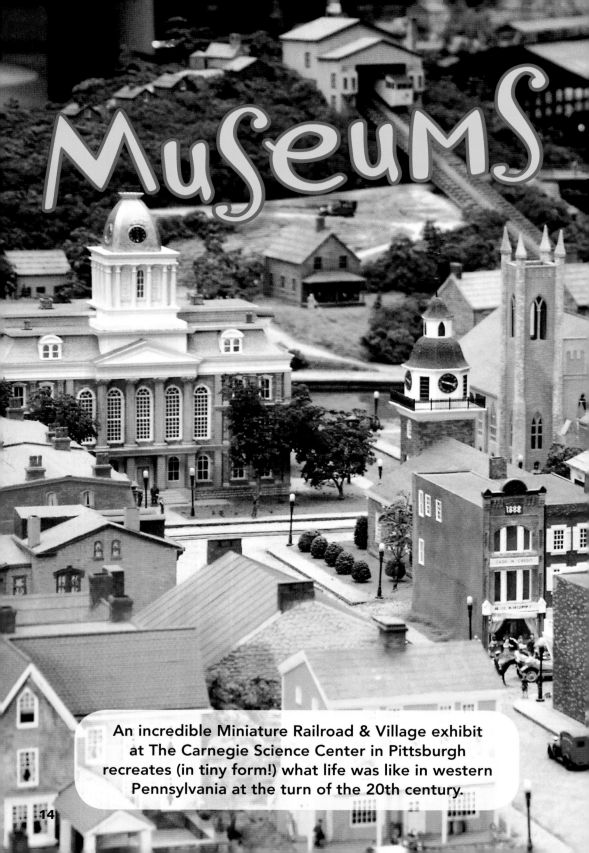

MUSEUMS

An incredible Miniature Railroad & Village exhibit at The Carnegie Science Center in Pittsburgh recreates (in tiny form!) what life was like in western Pennsylvania at the turn of the 20th century.

Museums don't just tell you about history—they make history come alive by showing you artifacts from times past. What's an artifact? It's any object that is actually produced by a human.

Why are Pennsylvania's museums so special?

Pennsylvania museums contain amazing exhibits with artifacts that tell many different stories. The Little League Baseball Museum in South Williamsport tells the story of how this sport grew from just thirty players in the 1930s to more than 2 million players today.

What can I see in a museum?

An easier question to answer might be, "What can't I see in a museum?" The State Museum of Pennsylvania—in the capital city of Harrisburg—has more than three million objects in its collections.

There are also plenty of hands-on exhibits in museums. For example, at the Carnegie Science Center in Pittsburgh, you can run, jump, climb, and test your reaction times as you learn about the physics of different sports!

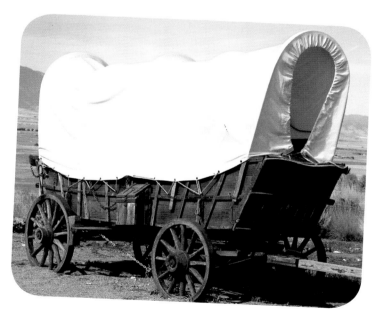

You can learn about Conestoga wagons like this one at the State Museum of Pennsylvania. First made near Lancaster, these wagons were the "big rigs" of the mid-eighteenth and early nineteenth centuries—except they were powered by a team of horses!

Forts

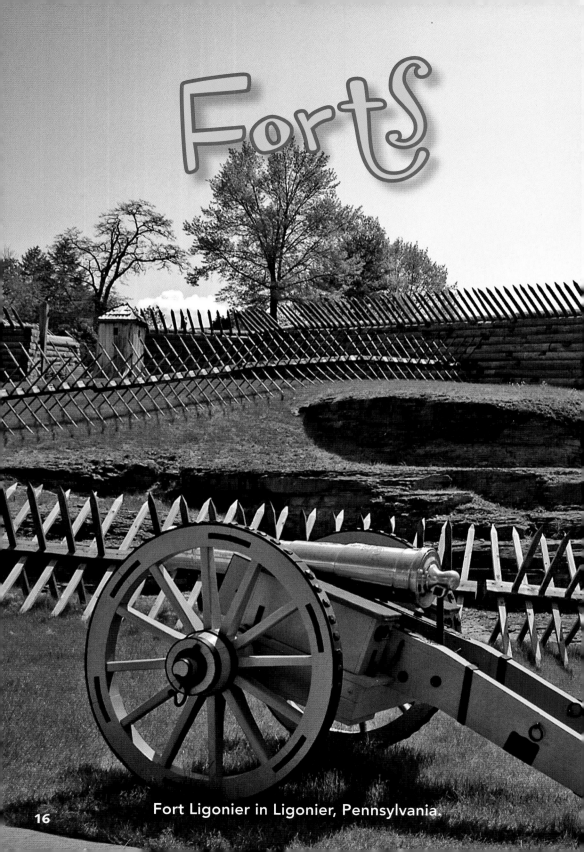

Fort Ligonier in Ligonier, Pennsylvania.

Long before the American colonists fought the British for their independence, the British clashed with the French for control of North America. Fort Ligonier was a British fort used in the mid-1700s. It is now restored and includes such sights as a blacksmith's shop, hospital, and soldier's barracks.

Why are forts special? (...and what is a fort, anyway?)

A fort is a place built for protection or defense. Forts were often built on high ground along an important transportation route. The inside of a fort was a self-contained community designed to survive long sieges, or battles. Barracks, storehouses, kitchens, and repair shops were built inside a fort. It had water and food supplies for the soldiers and sometimes for local people, too.

Besides Fort Ligonier, some of the other great forts in Pennsylvania's history include Fort Duquesne, Fort Necessity, and Fort Pitt. All of Pennsylvania's forts played important roles in the struggles of France, Great Britain, and the United States to win control of the land.

What can I see if I visit a fort?

Restored forts show you what life was like hundreds of years ago. You can see artifacts, including cannons and other weapons soldiers used. You can also see the places where the soldiers ate and slept. Sometimes there are re-enactments of battles.

...and there's more!

Even the forts that have mostly disappeared leave a footprint behind. Cities often build parks on these sites so people can sightsee and picnic.

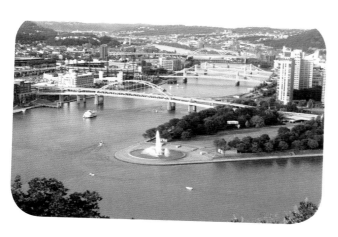

Both Fort Duquesne and Fort Pitt once stood where three rivers (the Allegheny, Monongahela, and Ohio) come together. This area is now included in the city of Pittsburgh where Point State Park preserves the heritage of the forts.

Well, how about...
the people!

Enjoying the Outdoors

More than twelve million people claim the Keystone State as their home. So it should be no surprise that there are many different viewpoints throughout the state. Yet Pennsylvanians still have plenty in common.

Many share a love of the outdoors. Pennsylvania has four distinct seasons so the choices for activities change all year long. Camping and hiking in the fall, skiing and sledding in the winter, rafting and biking in the spring, and swimming and fishing in the summer—the list of activities that Pennsylvanians enjoy goes on and on!

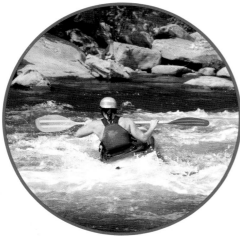

Whitewater rapids bring kayakers to Ohiopyle State Park every spring.

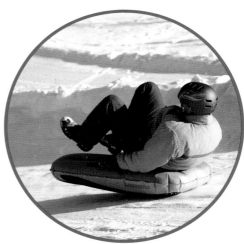

Ample snow makes for great "tube sledding" in winter.

Sharing Traditions

In the towns and cities throughout the state, Pennsylvanians share the freedom to celebrate different heritages. The great mix of cultures makes the state an interesting and exciting place to live.

Have you ever seen a beautiful Amish quilt? All of them are sewn by hand—it's a special skill passed down from generation to generation. Cooking is another way to pass on traditions. Have you ever tasted a Philadelphia cheesesteak? What about an Italian stromboli or maybe a Polish pierogi? These foods come from many cultures, but they are enjoyed at tables all over the state!

Making quilts is just one of many Amish traditions.

Pennsylvania apples make a great-tasting strudel.

Hikers can see beautiful leaf colors in the fall.

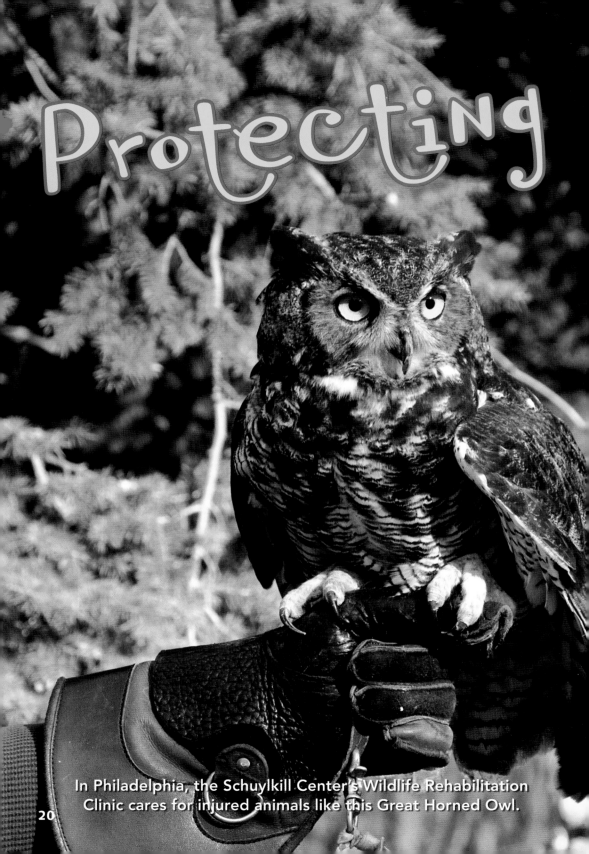

Protecting

In Philadelphia, the Schuylkill Center's Wildlife Rehabilitation Clinic cares for injured animals like this Great Horned Owl.

Protecting all of Pennsylvania's natural resources is a full-time job for many people!

Why is it important to protect Pennsylvania's natural resources?

The state of Pennsylvania is about 300 miles wide, so it has lots of different environments within its borders. The land changes across the state. From the Lake Erie shoreline to rolling hills and mountains—all of these different environments mean many different plants and animals can live throughout the state. In technical terms, Pennsylvania has great biodiversity! This biodiversity is important to protect because it keeps the environments balanced and healthy.

What kinds of organizations protect these resources?

It takes a lot of groups to cover it all. The U.S. Fish and Wildlife Service is a national organization. The Pennsylvania Department of Conservation and Natural Resources and the Pennsylvania Bureau of State Parks are state organizations. Of course, there are many other groups, such as the Audubon Society and the Rachel Carson Council, too.

And don't forget...

You can make a difference, too! It's called "environmental stewardship"—and it means you are willing to take personal responsibility to help protect Pennsylvania's natural resources.

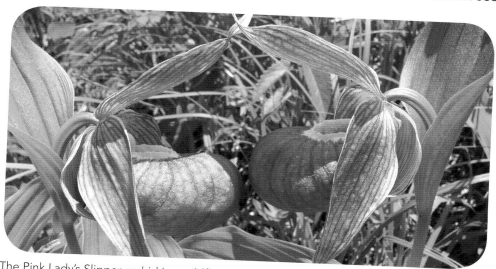

The Pink Lady's Slipper orchid is a wildflower in Pennsylvania that is protected by the Private Wild Plant Sanctuary program.

Creating Jobs

Pennsylvania is a leading producer of eggs—so even the chickens in the state work hard!

Pennsylvania grows more mushrooms than any other state.

Coal mining has been big in Pennsylvania since the mid-1700s. For many years coal was an important partner to Pennsylvania's steelmaking industry.

Military training is hard work!

Some jobs have been done in Pennsylvania for a long time. Farming is one of them. Other jobs, such as those in the high-tech and energy industries, are growing in demand.

What kinds of jobs are available throughout the state?

Agriculture is huge in Pennsylvania. Mushrooms, soybeans, corn, and oats are just some of the crops grown in the state. But farmers do more than grow plants. Raising livestock, such as cattle and chickens, is important, too.

The manufacturing of computer and electronic equipment is an expanding business in Pennsylvania. Energy industries are now providing jobs for many Pennsylvanians.

May I help you?

Another big industry is the service industry. Chefs, waiters, hotel clerks, and many other jobs are needed to help tourists sightsee, eat, and relax.

Don't forget the military!

The Air Force, Army, Coast Guard, and Navy all have a presence in the state. Pennsylvanians have a great respect for all the brave men and women who serve our country.

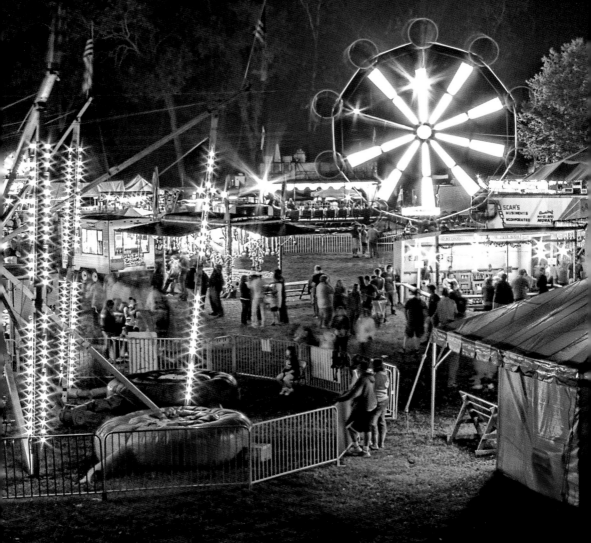

Celebrating

Many people enjoy the Denver Fair in Lancaster County.

The people of Pennsylvania really know how to have fun! Instead of just one big state fair—they have over one hundred county fairs! More than five and one half million visitors attend these fairs that take place all over the state.

Why are Pennsylvania festivals and celebrations special?

Celebrations and festivals bring people together. From cooking contests to music festivals, events in every corner of the Keystone State showcase all different kinds of people and talents.

What kind of celebrations and festivals are held in Pennsylvania?

Too many to count! But one thing is for sure. You can find a celebration for just about anything you want to do.

Have you ever seen carving that's done with a chainsaw? Each year 25,000 people gather in Ridgway, Pennsylvania, to watch chainsaw carvers create amazing art.

Meyersdale, Pennsylvania, has one of the sweetest festivals in the state. Their Maple Syrup Festival has been going strong for more than sixty years.

...and don't forget the groundhog!

Each year the famous weather expert—Punxsutawney Phil—comes out of his burrow on February 2 (Groundhog Day) to predict how long wintry weather will last (but it's all in fun!).

You just might find a carving like this one at the Ridgway Rendezvous of chainsaw carvers.

You can take a hot-air balloon ride at the Keystone International Balloon Festival in Lancaster.

Birds and Words

What do all the people of Pennsylvania have in common? These symbols represent the state's shared history and natural resources.

State Bird
Ruffed Grouse

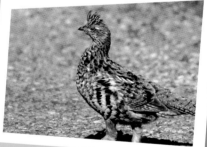

State Tree
Eastern Hemlock

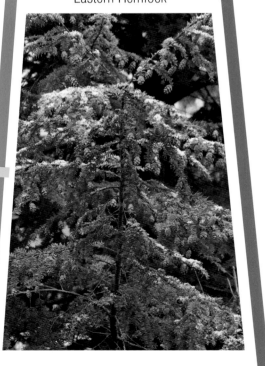

State Flower
Mountain Laurel

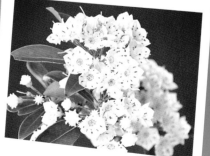

State Animal
White-tailed Deer

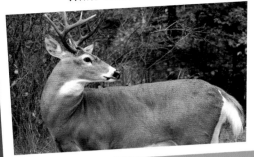

State Flag
Adopted June 13, 1907

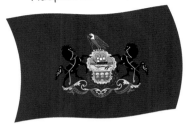

State Insect
Firefly

Commonly called a "lightning bug," this little insect flashes its light on warm summer nights to attract a mate.

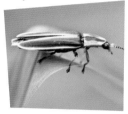

State Dog
Great Dane

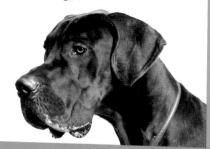

State Fish
Brook Trout

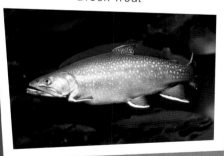

State Beverage
Milk

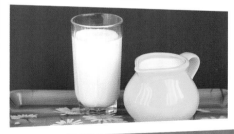

Want More?

Statehood—December 12, 1787
State Capital—Harrisburg
State Nickname—The Keystone State; The Quaker State
State Song—"Pennsylvania"

State Fossil—Trilobite
State Plant—Penngift Crownvetch
State Ship—U.S. Brig *Niagara*
State Motto—"Virtue, Liberty, and Independence"

More Fun Facts

More
Here's some more interesting stuff about Pennsylvania.

International Neighbor
The Great Lake of Erie separates part of the northern border of the state and Canada.

More Neighbors
New York, New Jersey, Delaware, Maryland, West Virginia, and Ohio all share borders with Pennsylvania.

Former National Capital
For ten of the early years in the country's history, **Philadelphia** served as the capital of the United States.

An Honored Father
Pennsylvania means "Penn's Woods." The name honors founder William Penn's father.

Revolutionary Tribute
A statue in **Carlisle** honors Mary Ludwig Hayes McCauley and all of the other women who helped their soldier husbands during the Revolutionary War. These women all got the same nickname—Molly Pitcher—because they carried water to the troops.

A Colorful Attraction
You can learn about the history of crayons at the Crayola Factory, the company's hands-on museum, in **Easton**.

A National Forest
The Allegheny National Forest was established in 1923. It's the only national forest in the state.

Internet Savvy
Back in 1999, Pennsylvania was the first state to list its official web site URL on license plates. (Now they use the tourism website: visitPA.com)

Electric City
In 1886, the nation's first electrified streetcar, or trolley, system was established in **Scranton**.

Pennsylvania Painter

Andrew Wyeth, one of the best known artists of the 20th century, was born in **Chadds Ford**, Pennsylvania.

Pocket Change

The United States Mint in **Philadelphia** produces lots of coins—between 11 and 20 billion each year!

A Tasty Honor

The town of **Hershey** is considered the chocolate capital of the United States. It is the nation's top chocolate producer.

The Fast Lane

The country's first multilane highway was the Pennsylvania Turnpike, which crosses the width of the state.

What's in a Name?

Bird-in-Hand and **Paradise** are just two of the places you can visit in Pennsylvania's Dutch Country.

Feels Like

Paul A. Siple grew up in **Erie** and became an Antarctic Explorer who helped develop (and coined the term) the "wind chill factor."

Top Banana

The city of **Latrobe** takes great pride in celebrating Dr. Dave Strickler's invention of the banana split in 1904.

Forever Cracked

The Liberty Bell (displayed in **Philadelphia**) cracked when it was first rung in 1752. It was recast twice…but cracked again. The bell rang for the last time to celebrate George Washington's birthday in 1846.

Hide the Bell

From the fall of 1777 to the winter of 1778, the Liberty Bell was hidden in a church in **Allentown** to keep it from the British Army.

The Quaker State

Pennsylvania earned this nickname because of the religion of its founder, William Penn, and the other Quakers who settled in the state.

Check It Out

The first lending library opened in **Philadelphia** in 1731.

Find Out More

There are many great websites that can give you more information about the exciting things that are going on in the state of Pennsylvania!

State Websites

The Official Government Website of Pennsylvania
www.pa.gov

Pennsylvania State Parks
www.dcnr.state.pa.us/stateparks

The Official Tourism Site of Pennsylvania
www.visitpa.com

Museums/Erie

The Erie Art Museum
www.erieartmuseum.org

Harrisburg

The State Museum of Pennsylvania
www.statemuseumpa.org

Hershey

The Hershey Story—The Museum on Chocolate Avenue
www.hersheystory.org

Philadelphia

The African American Museum in Philadelphia
www.aampmuseum.org

Philadelphia Museum of Art
www.philamuseum.org

Pittsburgh

Carnegie Museums of Pittsburgh
www.carnegiemuseums.org

Punxsutawney

Punxsutawney Weather Discovery Center
www.weatherdiscovery.org

Williamsport

Peter J. McGovern Little League Museum
www.littleleague.org/learn/museum.htm

Aquarium and Zoos

Pittsburgh Zoo & PPG Aquarium
www.pittsburghzoo.org

Philadelphia Zoo
www.philadelphiazoo.org

ZooAmerica—North American Wildlife Park (Hershey)
www.zooamerica.com

Pennsylvania: At A Glance

State Capital: Harrisburg

Pennsylvania Borders: New York, New Jersey, Delaware, Maryland, West Virginia, Ohio, and Lake Erie

Population: More than 12 million

Highest Point: Mount Davis, 3,213 feet above sea level

Lowest Point: Sea level at the Delaware River

Some Major Cities: Philadelphia, Pittsburgh, Allentown, Erie, Reading, Lancaster, Bethlehem, Scranton, Harrisburg, Wilkes-Barre, Hazelton

Some Famous Pennsylvanians

Louisa May Alcott (1832–1888) born in Germantown; was an American novelist best known for *Little Women*, a story based on the Alcott family.

Guion S. Bluford, Jr. (born 1942) from Philadelphia; is an astronaut who was the first African American to travel in space, on the *Challenger* in 1983.

James Buchanan (1791–1868) from Mercersburg; was the 15th President of the United States, from 1857–1861.

Rachel Carson (1907–1964) from Springdale; was a biologist and author who wrote about environmental issues. Her most famous book is *Silent Spring*.

Mary Cassatt (1844–1926) from Allegheny; was a painter and printmaker whose subjects often included mothers and their children.

Bill Cosby (born 1937) from Philadelphia; is a comedian, actor, author, television producer, educator, and activist.

Patti Labelle (born 1944) from Philadelphia; is a Grammy Award–winning rhythm and blues and soul singer.

Tara Lipinski (born 1982) from Philadelphia; is an athlete who won the Olympic gold medal in figure skating at the age of 15.

George C. Marshall (1880–1959) from Uniontown; was a five-star general, Chief of Staff of the Army, Secretary of State, Secretary of Defense, and Nobel Peace Prize winner.

Fred Rogers (1928–2003) from Latrobe; educator, minister, songwriter, and television host of the long-running children's program "Mister Rogers' Neighborhood."

Betsy Ross (1752–1836) lived in Philadelphia and was a seamstress who many think made the first American flag.

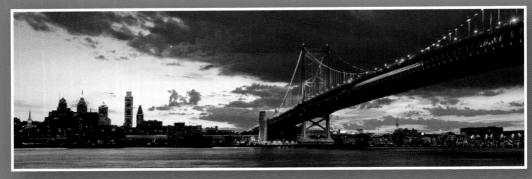

Benjamin Franklin Bridge over the Delaware River.

CREDITS

Series Concept and Development
Kate Boehm Jerome

Design
Steve Curtis Design, Inc. (www.SCDchicago.com); Roger Radtke, Todd Nossek

Reviewers and Contributors
Content review: Dr. Karen Guenther, Professor of History, Mansfield University; Contributing writers/editors: Terry B. Flohr; Stacey L. Klaman; Research and production: Judy Elgin Jensen; Copy editor: Mary L. Heaton

Photography
Back Cover(a), 26c © Andrew Williams/Shutterstock; Back Cover(b), 18a © Joy Fera/Shutterstock; Back Cover(c), 16-17 by Jeff Kubina; Back Cover(d), Cover(a), 4-5, Cover(d) © Jeffrey M. Frank/Shutterstock; Back Cover(e) by Elizabeth M. Lynch; Cover(b), 27(a) © Mike Rogal/Shutterstock; Cover(c), 6-7 © Dion Widrich/iStockphoto; Cover(e), 9 © Caleb Foster/Shutterstock; Cover(f) © Jonathan Smith/Shutterstock; 2-3, 18-19 © SNEHIT/Shutterstock; 2a © Caitlin Mirra/Shutterstock; 2b © Nathan Jaskowiak/Shutterstock; 3a, 7b © Delmas Lehman/Shutterstock; 3b, 27c © Andrea Gingerich/iStockphoto; 5a © Jason Lugo/iStockphoto; 5b © Curt Weinhold; 7a © PeJo/Shutterstock; 8-9 © Terry McCormick; 10-11 by Wally Gobetz; 10a Courtesy of The State Museum of Pennsylvania, Pennsylvania Historical and Museum Commission; 11a © Stephen Coburn/Shutterstock; 11b Courtesy of The Ohio Historical Society; 12-13 by Jen Goellnitz; 13a © K.L. Kohn/Shutterstock; 13b by Daderot/from Wikimedia; 14-15 by Patty Rogers, Miniature Railroad & Village®, Carnegie Science Center; 15 © Rita Robinson/iStockphoto; 17 © Steve Broer/Shutterstock; 18b © Marcel Jancovic/Shutterstock; 19a © Christina Richards/Shutterstock; 19b © Josef Bosak/Shutterstock; 20-21 Courtesy of The Schuylkill Center; 21 © Kirsanov/Shutterstock; 22-23 © Regina Chayer/Shutterstock; 23a © Chris leachman/Shutterstock; 23b © Lisa F. Young/Shutterstock; 23c © John Wollwerth/Shutterstock; 24-25 by Bob Jagendorf; 25a © fcarucci/Shutterstock; 25b © John Dorado/Shutterstock; 26a © Al Parker Photography/Shutterstock; 26b © hd connelly/Shutterstock; 27b © trubach/Shutterstock; 27d © Eric Isselée/Shutterstock; 27e © Eric Engbretson and U.S. Fish and Wildlife Service, 27f © HGalina/Shutterstock; 28 © Barbara Delgado/Shutterstock; 29a © BW Folsom/Shutterstock; 29b © JoLin/Shutterstock; 31 © R. Gino Santa Maria/Shutterstock; 32 © Steven Vona/Shutterstock

Illustration
Back Cover, 1, 4, 6 © Jennifer Thermes/Photodisc/Getty Images

ISBN 978-1-58973-021-2

Library of Congress Catalog Card Number: 2010935880

1 2 3 4 5 6 WPC 15 14 13 12 11 10

Published by Arcadia Publishing, Charleston, SC

For all general information contact Arcadia Publishing at:

Telephone 843-853-2070

Fax 843-853-0044

Email sales@arcadiapublishing.com

For Customer Service and Orders:

Toll Free 1-888-313-2665

Visit us on the Internet at www.arcadiapublishing.com